NEW YORK

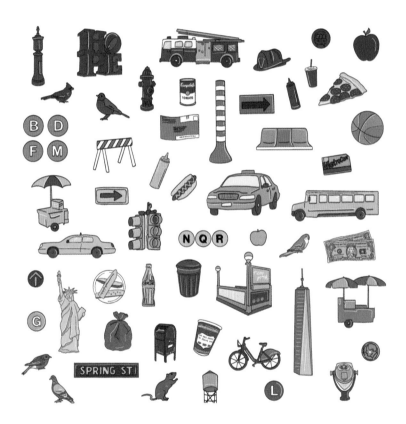

Megan McKean

Smith
Street
Books

What do you picture when you think of New York? A buzzing city, famous for its sunny yellow taxis and grey glass skyscrapers. The green copper of the Statue of Liberty is recognised around the globe, always tied to the image of New York City. Iconic hues are found all around the city, the specific shades contributing to what makes them so memorable.

All official taxi cabs were painted yellow in the 1960s, partially because yellow was particularly liked by the wife of the taxi company president. Had she had a fondness for pink, could we have seen rose-tinted taxis becoming so synonymous with NYC?

The city changes with the seasons, the burst of pastel cherry blossoms heralding the spring, and winter often bringing a white blanket of snow ... that quickly turns to brown slush and grey puddles to dodge on the streets. Once you start to notice the tints and tones of your surroundings, you can't help but build your own rainbow as you move through the city.

Red fire trucks zooming by, orange subway seats, yellow traffic lights, green pickles at the diner, blue Anthora coffee cups, the pink glaze of a strawberry donut – all making up the vibrant spectrum that is New York.

Katz's Deli
Pepperoni pizza
HOPE sculpture
Roosevelt Island Tram
Red brick buildings
Northern cardinals
Joe's Pizza
Fire trucks

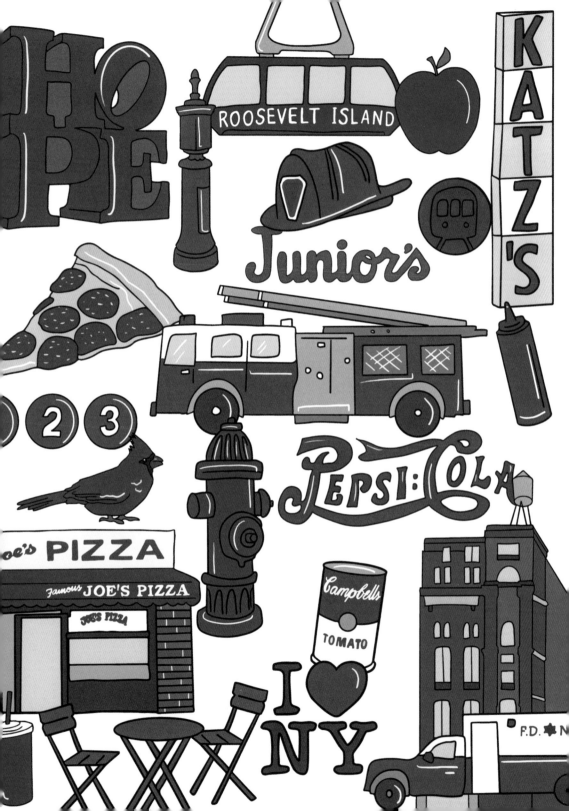

Steam stacks
Staten Island Ferry
Halloween pumpkins
Fall in Central Park
Parking tickets
Mandarin duck
Traffic cones
Basketballs

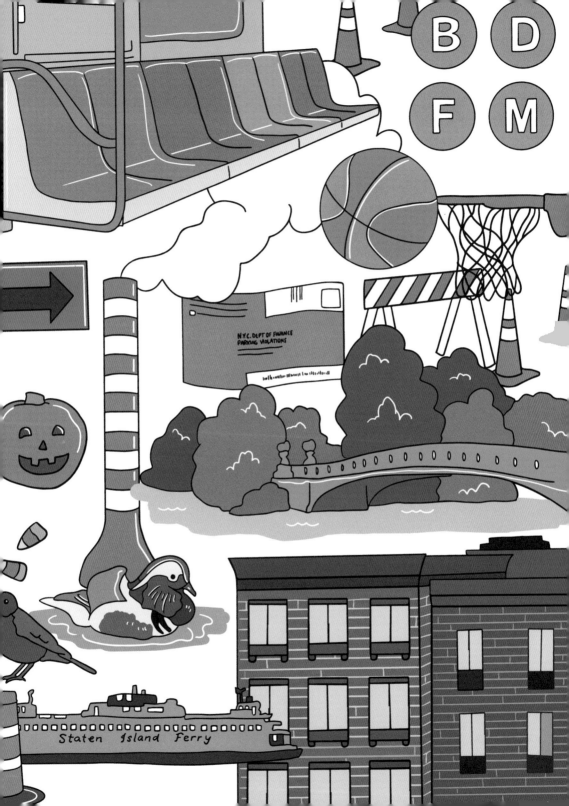

Taxi cabs
Traffic lights
School buses
Sunny-side up eggs
Subway Seats
MetroCards
Water taxis
Mustard

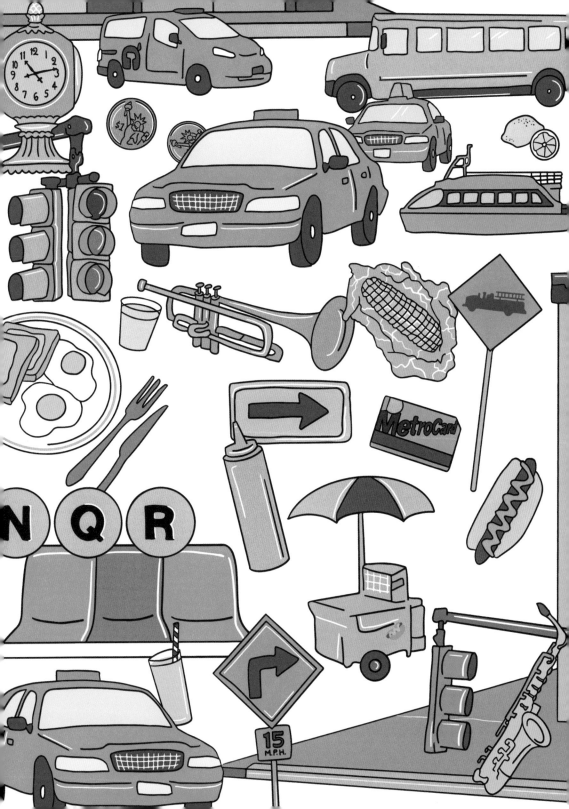

Street signs
Copper rooftops
Statue of Liberty
Warhol's Coca-Cola Bottles
Subway entrances
Vesuvio Bakery
Diner pickles
Trash cans

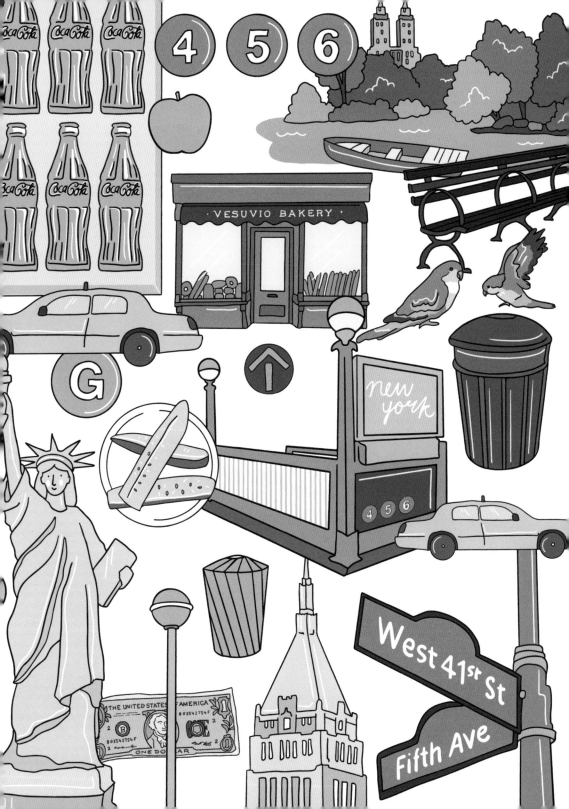

Mailboxes
Anthora coffee cups
Blue whale at AMNH
Bleecker Street subway
Grand Central ceiling
Manhattan Bridge
One World Trade
Citi Bikes

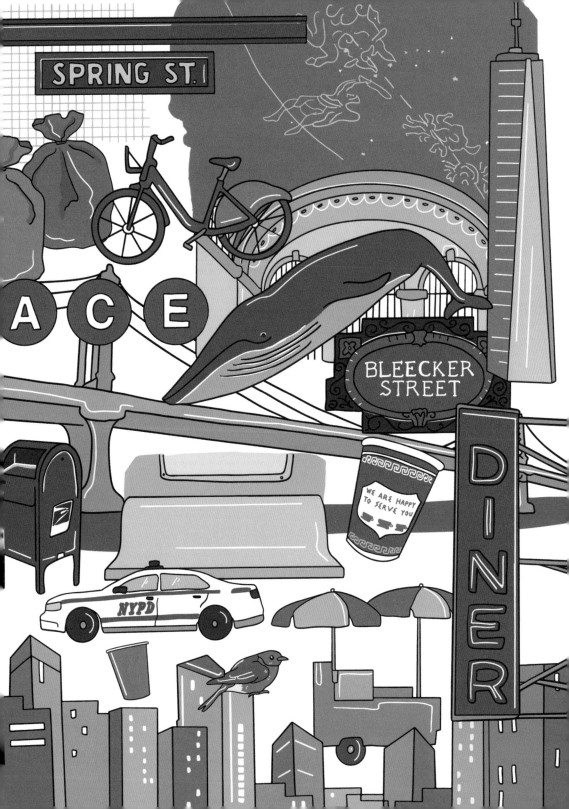

Pigeons
Martini shakers
Empire State Building
Nickels and dimes
Chrysler Building
Tourist binoculars
Manhattan skyline
Water towers

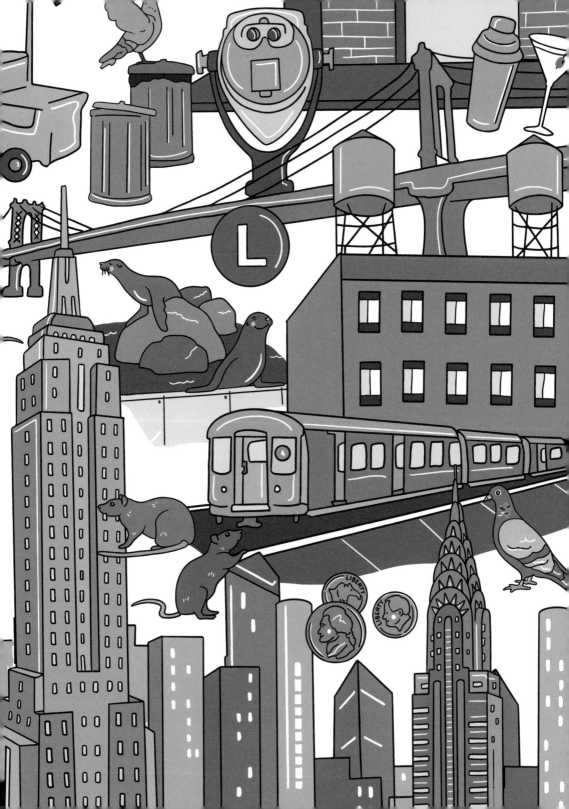

Pretzels
Delivery vans
Brownstones
Brooklyn Bridge
Everything bagels
Bull of Wall Street
Flatiron Building
Squirrels

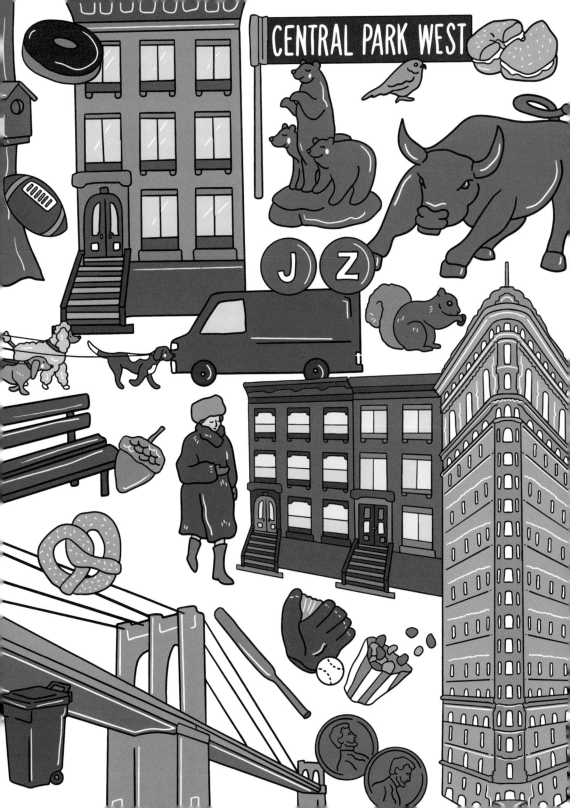

CENTRAL PARK WEST

J Z

The Guggenheim
Cream cheese bagels
Spot the Dalmatian
Black and white cookies
St. Patrick's Cathedral
Chocolate chip pancakes
The Oculus
The Plaza

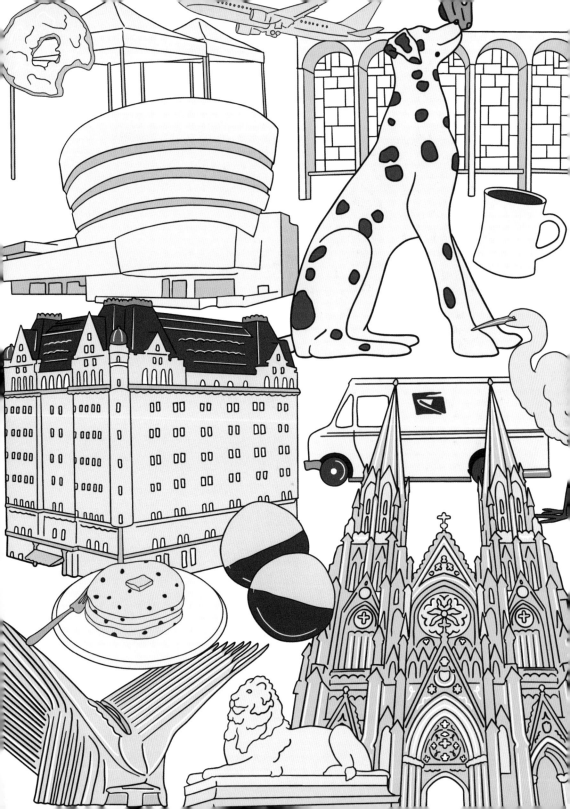

Rose lattes
Carrie Cupcakes
Strawberry donuts
Palazzo Chupi
Cherry blossoms
Ice cream trucks
Sprinkles ATM
Tiny's

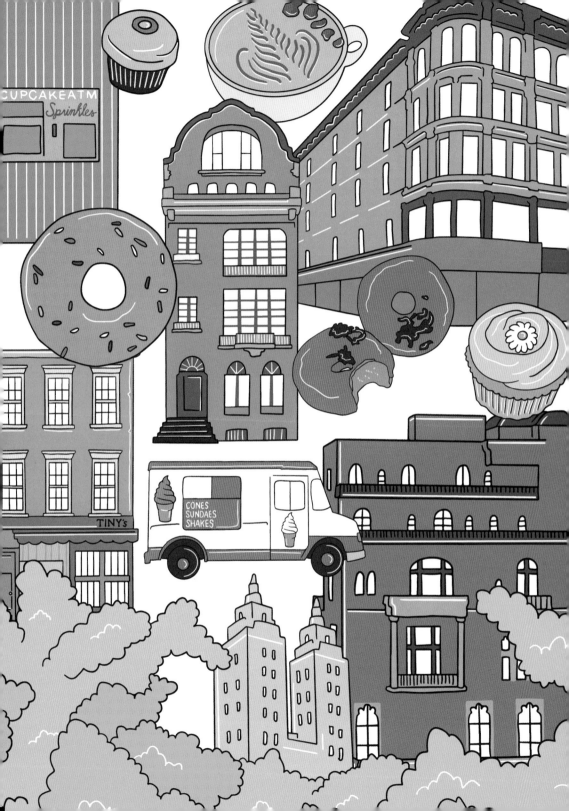

New
York

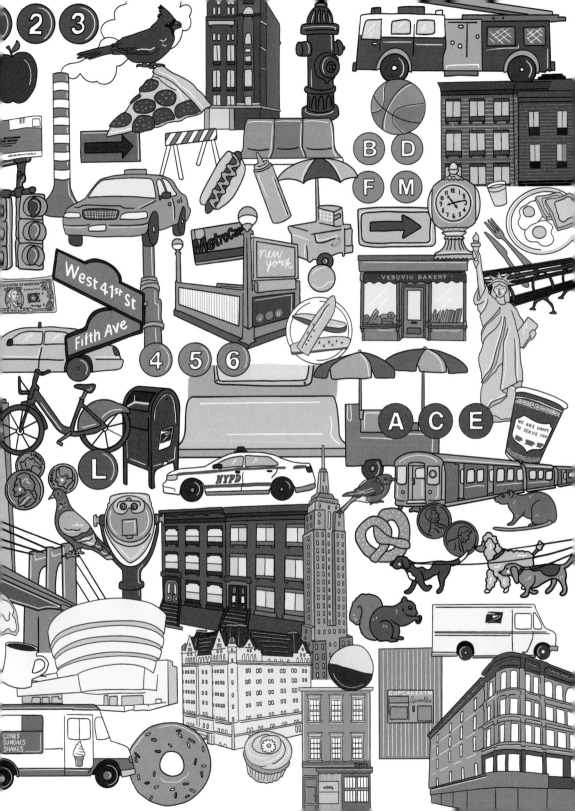

Published in 2023 by Smith Street Books
Naarm (Melbourne) | Australia
smithstreetbooks.com

ISBN: 978-1-9227-5449-3 (US) / 978-1-9227-5476-9 (UK & AU)

Smith Street Books respectfully acknowledges the
Wurundjeri People of the Kulin Nation, who are the
Traditional Owners of the land on which we work,
and we pay our respects to their Elders past and present.

Publisher: Paul McNally
Senior Editor: Hannah Koelmeyer
Design layout: Megan McKean
Proofreader: Rosanna Dutson

Printed & bound in China by C&C Offset Printing Co., Ltd.

Book 275
10 9 8 7 6 5 4 3 2 1

MIX
Paper | Supporting
responsible forestry
FSC® C008047

For Joshua

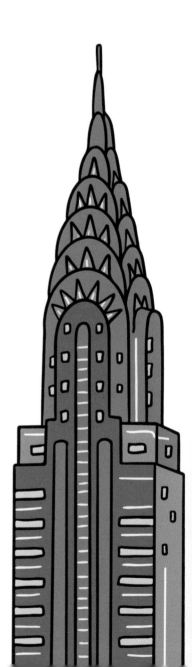